JAPAN'S URUSHI CRAFTSMEN

Can Old World Artistry Survive in the 21st Century?

Published by:
Chin Music Press
1501 Pike Place #329
Seattle, WA 98101
www.chinmusicpress.com

Cover art by Dan D Shafer with photographs from Heiando Inc.
Book design by Dan D Shafer

Printed in the USA

978-1-63405-010-4

JAPAN'S URUSHI CRAFTSMEN

Can Old World Artistry Survive in the 21st Century?

BRUCE RUTLEDGE

CHIN MUSIC
PRESS

in cooperation with **YAMADA HEIANDO**

SEATTLE & TOKYO

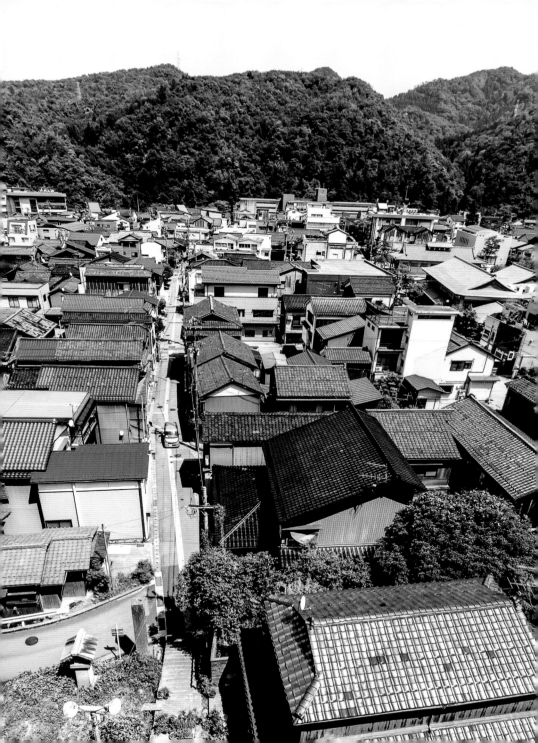

TABLE OF CONTENTS

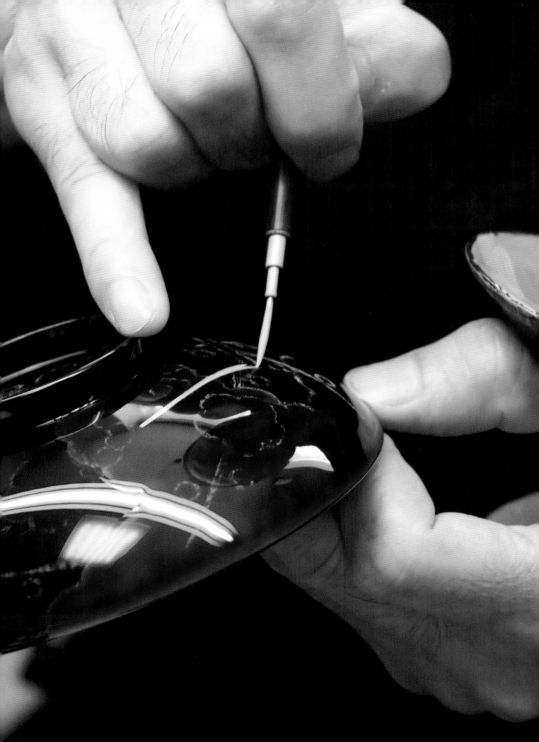

FOREWORD

DURING A WHIRLWIND TOUR OF western Japan in spring 2019, I interviewed several craftsmen who work with sap from the Asian lacquer tree to make exquisite pieces of lacquerware. I imagined these craftsmen working in well-lit art studios or museum-like surroundings. Instead, I found them working out of their homes or in a warehouse-like office, their work aprons stained coal black from the *urushi* sap. They had more in common with my high school friends who could dismantle and put back together a car engine than they did with, say, a world-famous painter or sculptor. And yet their work is unparalleled. One of the men I met had been interviewed by media all over the world and is considered one of the greatest living *maki-e* artists, maki-e being a technique of painting images on the lacquerware using powdered gold, silver, and other colors. He paints designs on watch faces that are so detailed you have to use a loupe to appreciate them. But he was no Andy Warhol— not the flamboyant, self-promoting type—which may have been one reason Yamada Heiando, a prestigious lacquerware company that has been a purveyor to the Japanese Imperial Family since 1919, asked me to fly to Japan and meet these artists.

The dilemma is this: the urushi craftsmen (and, alas, they are all men) have a dangerous combination of well-honed skills and humility that doesn't always play well in an age of social media likes and retweets. Plus, their products are so well made and durable that the shrinking Japanese populace can't muster up the demand to keep the craftsmen in business. Lacquerware bowls and trays are passed down from generation to generation in Japanese families. The sturdy kitchenware is made even more robust when urushi is applied. These items last a lifetime and beyond.

There's also this little problem with plastic knockoffs. To the untrained eye, the red and black plastic bowls and trays you'll find at any Japanese thrift shop aren't that different from the handmade urushi pieces, and they cost a fraction of what good lacquerware items cost. Of course, if we think for a moment about the long-term environmental impact of cheap, plastic knockoffs, the cheaper choice shouldn't be so automatic. But this is the early twenty-first century, and convenience is still king.

Japan's urushi industry must look overseas for demand. Unfortunately, the craftsmen are ill-equipped for that task. They don't talk up their work. They are not savvy marketers. They are craftspeople who have devoted their adult lives and much of their childhoods to making lacquerware. I followed them through their workdays and never saw them peek at a cellphone. Not once. When they work, they are fully in the moment. They must be because their work is extremely detailed and constantly fraught with the possibility of failure. Everything is done by hand. One mistake along the way and that bowl or tray or vase ends up in the trash heap.

I was sent to such farflung destinations as Yamanaka Onsen near the Japan Sea coast and Sabae (Japan's eyeglass capital) in Fukui Prefecture to watch these men work, to talk to them, and to chronicle what they do. Will this be the last generation to do this arduous work? Perhaps. But if the world fell in love with the lacquerware they create, perhaps a different fate could be had.

Bruce Rutledge
Seattle, 2019

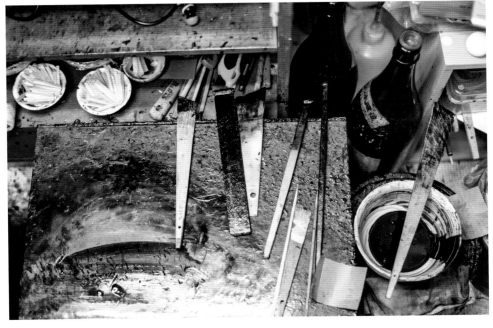

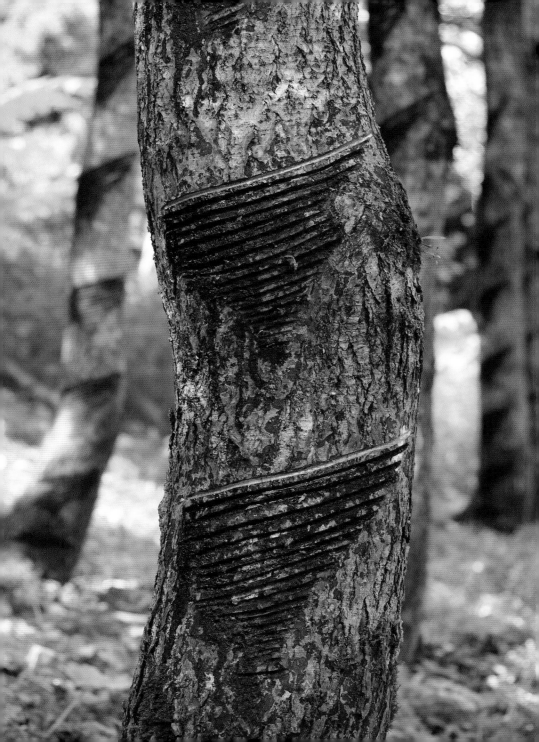

A BRIEF HISTORY OF URUSHI

THE FIRST KNOWN USE OF urushi lacquer dates to the Stone Age. Back then, people were drawn to the sap's adhesive qualities, which let them mount points on spears and arrows. In Japan, there is evidence of use as far back as seven thousand years ago, during the Jomon Period. People recognized the durability and aesthetic beauty of the lacquer and applied it to pottery, wooden items, baskets, objects made of bone, and burial clothing for the dead.

When Buddhism was introduced to Japan from Korea in the sixth century CE, urushi was used to create images of the Buddha and other religious iconography. The lacquer was widely used in temples. Over time, the making of lacquerware became a thriving industry connected closely with Buddhism. Along with its use in temples, it was painted on bowls, trays, sake cups, boxes, combs, and other objects. Urushi has a practical beauty: it can both enhance the look and feel of a product and also repel water, protecting the object from rot. Over the centuries, it has become an integral part of Japan's spiritual life as well as its kitchens and dining rooms.

As Japanese civilization developed, so did the techniques for applying urushi. Craftsmen became more sophisticated and looked for more ways to stand out in a crowded marketplace. In the Nara Era (710-794), the art of maki-e was born. Maki-e, literally "sprinkled pictures," uses different powders, including gold dust, to create designs on the lacquered surface.

Fast forward to the twelfth century, when Buddhist monk Eisai introduced Japan to Zen Buddhism and powdered green tea, or matcha, after his trips to China. As the tea ceremony evolved in Japan, it was another boon for the lacquerware industry because many of the utensils, tools, tea containers, and incense holders used in the ceremony were lacquered. In fact, they still are today.

Urushi seems to have a role in every aspect of Japanese life. It also played a significant part in Japan's martial past, having been used to coat the armor, helmets, and swords of samurai and other soldiers.

In the Edo Period (1603-1868), an era when Japan's homegrown culture thrived, urushi products such as chopsticks, multi-tiered boxes, medicine cases, hair pins, and combs became all the rage. Today, urushi hair combs are still worn when women don traditional kimonos.

Over the centuries, many ways of applying urushi have been developed. Here are just a few of the most widely used techniques:

Kamakura-bori | Designs are carved into wood, and then urushi is layered on top.

Keyaki | Keyaki is the Japanese word for the Zelkova serrata tree. Its wood is highly prized by craftspeople for its beautiful grain. Urushi applied to a bowl or cup carved from keyaki has a warmth and natural dynamism to it.

Maki-e | Artists with decades of experience use a fine brush to paint a picture on the wet urushi then sprinkle ultrafine gold dust and other powders on it while the urushi dries.

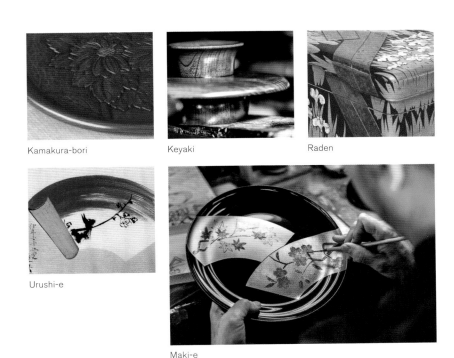

Kamakura-bori

Keyaki

Raden

Urushi-e

Maki-e

Raden | Designs and pictures are polished into the shiny inner layer of seashells, giving off a natural luster.

Urushi-e | Patterns and pictures are painted with different-colored urushi.

Today, urushi is finding new uses on watch faces, jewelry, cosmetics cases, and in boxes for high-end chocolates, for example. There is even a bar in Tokyo's Roppongi nightclub district that is coated from floor to ceiling in urushi. But much work remains to be done to ensure that traditional Japanese lacquerware does not become a thing of the past. Its beauty and durability are made for an era that values conservation over convenience.

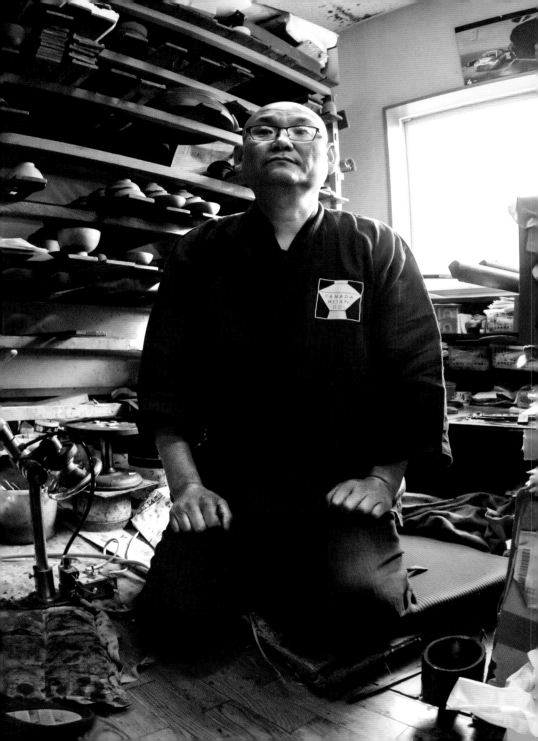

The Shokunin Interviews:

APPLYING THE BASE LAYER

YAMANAKA ONSEN IS A CHARMING hot-springs town filled with elderly travelers who, between soaks in the energizing, mineral-rich baths, shop and dine along the main street or walk along the paths of the Kakusenkei Gorge, looking down at the Daishoji River as it rushes by. The gorge is said to have inspired famed poet Matsuo Basho to write:

> *Here*
> *The joy of a good*
> *Outdoor walk*

It's a short walk—the path runs for just more than a kilometer—but joyous, nonetheless. Stay in Yamanaka Onsen for a little while and you begin to understand why the Japanese live such long lives. The mountain air is crisp and fresh, the food plentiful and delicious, and the baths restorative. Plus, rent for a large apartment is less than six hundred dollars a month. Life is good in Yamanaka Onsen.

A short drive from town is where Masahiro Tanaka applies the first layer of urushi to bowls and trays delivered to him from woodworkers. He works on the first floor of his boxy green house in a room just off the entranceway. Signs of a busy family are everywhere. A five-tier rack by the door is filled with shoes; a bucket of baseballs sits on a table in the garage next to boxes and a stack of spare tires. The second floor of the house is reserved for the family.

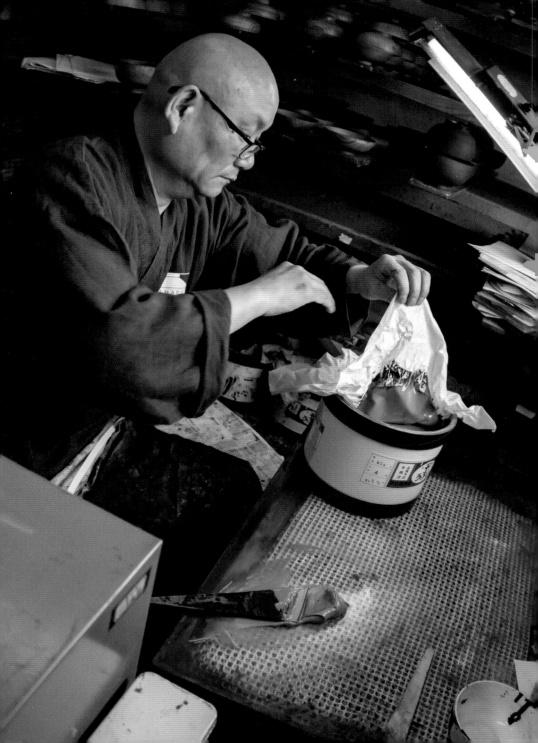

In his workshop, Tanaka sits on a cushion on the floor, *zazen* style, a tall rack of bowls to his left and stacks of paper and bowls to his right and in front of him. He keeps a small space clear on the low-slung table. This is where he mixes the first layer of lacquer. He works with a mix of sap from the lacquer tree, called *kiurushi*, and an earth-based pigment called *tonoko*, which has been baked and crushed. Tanaka kneads this concoction together, working quickly and rhythmically with his hardened brushes and wooden spatulas until the lacquer is the right consistency to apply to the bowls. Timing is critical. Urushi is famously temperamental.

Once the urushi is the right consistency, he takes a wooden bowl and places it on a small, rotating stand that sits on his lap. His left hand holds the stand steady. The bowl adheres to the center of the stand. With his right hand, Tanaka applies a coat of urushi to his spatula and coats the inside of the bowl at the very bottom with a circle of lacquer, his left hand rotating the stand. He works quickly, applying the lacquer to the inside bottom first. He repeats this process on a series of bowls.

When Tanaka breaks his concentration and looks up to chat with me, he's friendly and forthright. When I mention he has the same name as a pitcher for the New York Yankees, he says quickly, "I'm the original." Seeing the photos of his son in a little league uniform, I'm guessing this is a line he's delivered before.

Tanaka says that since he was a young boy, he wanted to be a *shokunin*, or craftsman. "Since we were little, our generation was told that we would continue with our father's work. It was just expected. When I was asked to write down my dream job in elementary school, I wrote 'shokunin.' Now, I wonder, what was I thinking?" he says with a laugh.

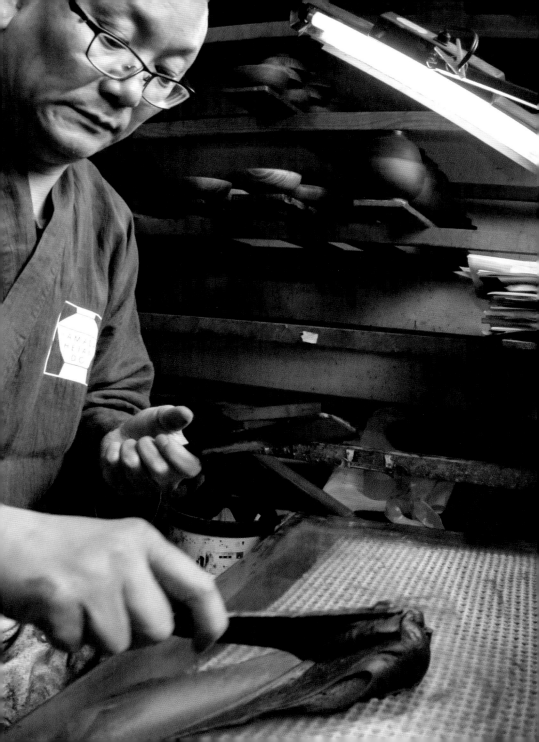

"Shokunin" (職人) literally means "craftsperson," "artisan," or "worker." But what echoes in the ear of a Japanese speaker when they hear the word is something more like "a person with a deep commitment to his or her craft." In 2018, the Portland Japanese Garden held an exhibit entitled "Shokunin: Five Kyoto Artists Look to the Future." The garden's definition of "shokunin" captures the spirit of Tanaka and his brethren:

"The word 'shokunin' means 'artisan,' a word that signifies a person who has achieved a high level of accomplishment and a deep commitment to carry on the legacy of a traditional craft. A shokunin who works in the twenty-first century is an artisan whose work shows respect for the traditions of fine craftsmanship that have been handed down for generations—the handmade tools, the time-honored techniques, the finest natural materials, and the patience and indomitable spirit needed to carry on a painstaking craft.

"Just as important is the understanding that the work of each Japanese artisan is an expression not only of an individual artisan but a collaborative effort among the many who work to complete a single process. From the lumberjack to the wood-turner to the artisan who applies the final exquisite layer of lacquer, the work of the shokunin is the work of an entire community of fine craftsmen and women, each of whom plays a critical role in the creation of a finished vessel."

It's that social contract, that shared sense of duty, which adds the meaningful nuance to the term "shokunin." The wood-turner, Tanaka, the craftsman who applies the final layer, and the maki-e artist are all in this together. Each bowl and plate goes through a line of shokunin who are bonded by their collaborative effort.

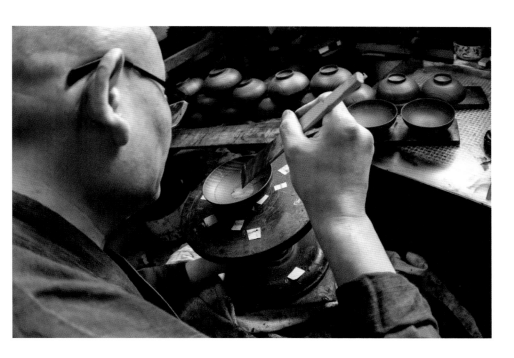

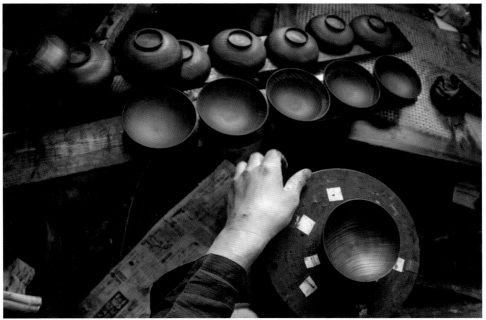

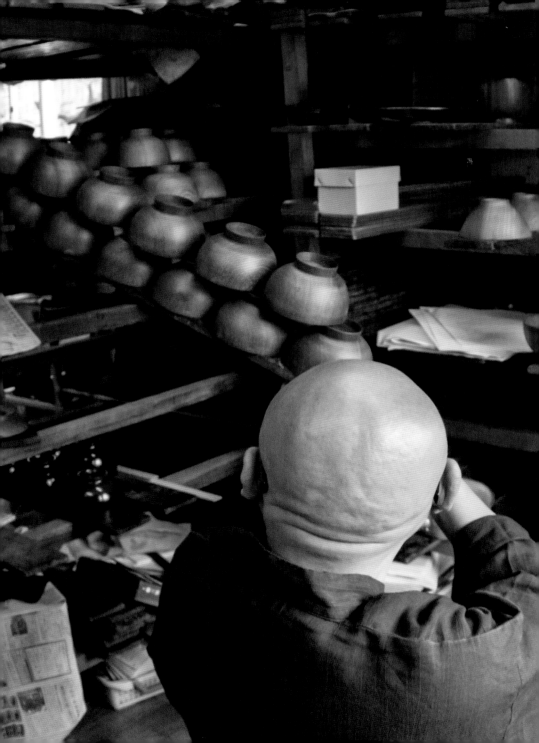

Tanaka says he takes pride in his work and expects others in the supply chain to do the same. "Of course, if the woodworker does his job right, my job is a lot easier. If I do a good job, then the person doing the next layer has it easier, too. If all the craftsmen do their work precisely, we can make a beautiful, good product," he says. "That is where the craftsmen's pride comes in. We must do a good job."

The urushi sap that Tanaka works with contains the same kind of allergic oil as poison ivy or poison oak. The sap is extracted from the urushi tree by making horizontal slashes in the tree, allowing the sap to ooze out. The urushiol, as the sap is called, is filtered through a special paper until the toxins are reduced and eventually eliminated. What's left is a viscous liquid that is sometimes transparent, sometimes amber hued.

Tanaka has known this work all his life, having watched his father do it during his childhood. But tellingly, when asked if he expects his son to become a third-generation shokunin, he replies without a pause: "No. I would not recommend this work to him. This industry is pretty tough. I can't tell my child that it's a good option for him." Later he adds, "Perhaps I shouldn't say this, but it's hard to make money doing this work."

Tanaka recalls how he used to come home from school and watch his dad work. "Yamanaka is a center of lacquerware, so we're all used to coming home and seeing our dads working in the house," he says. "There were so many craftsmen back then. Today, there's not many of us left."

Tanaka started in his father's footsteps as soon as he graduated high school, nearly thirty years ago. His typical workday begins around eight-thirty or so with prep work. He starts applying the urushi coating around nine and keeps at it until seven-thirty or eight at night. "But there are times when I get a rush order, and I work late into the night," he says.

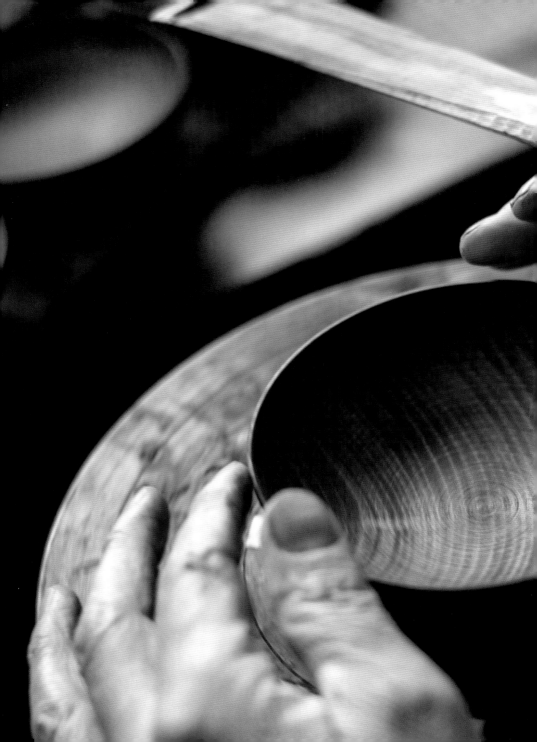

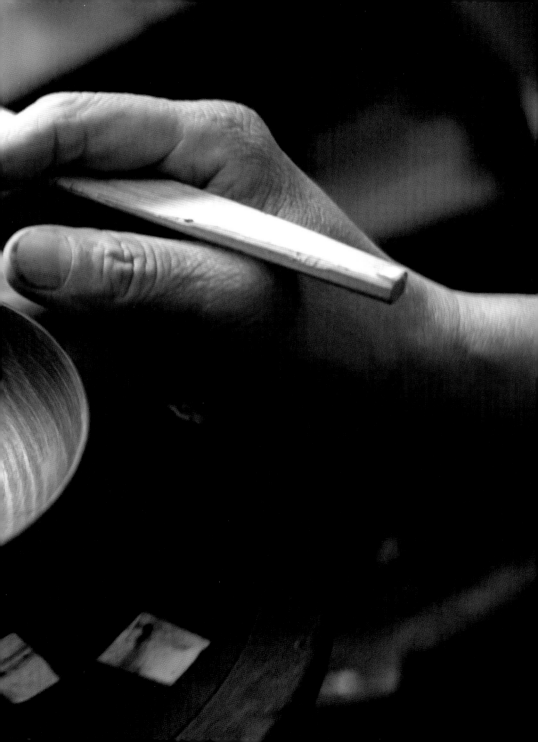

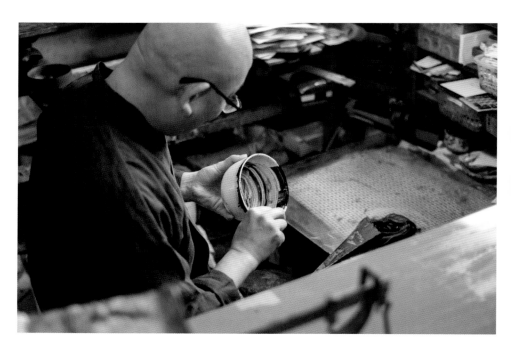

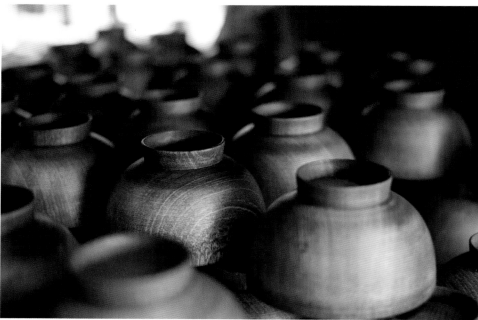

When I ask him how many bowls he coats in a day, he explains, "It's not about the volume, because I apply several layers to each bowl, but I guess it would be about two hundred a day."

He explains that as he gets close to finishing the initial layer on each bowl or plate, his concentration ratchets up a notch. "As we near completion, we get more detailed. We focus on the surface. We can't let moisture get into the wood. If it does, the product won't last long."

Tanaka (and all the craftspeople I talked to) works for Heiando, a 101-year-old company in Tokyo that has been the purveyor of lacquerware to the Imperial Household for more than ninety years. Despite that prestigious connection, the state of the lacquerware industry weighs on Tanaka. But he is not without hope for the future. A nearby school, the Ishikawa Prefectural Institute for Yamanaka Lacquerware, is attracting students from all over the country who want to do this work, including a fair number of female students. Tanaka says, "I think the numbers will go up in the future. People from other places find this sort of work attractive. I teach over there sometimes."

We'll visit that institute and the hope for the industry in chapter six.

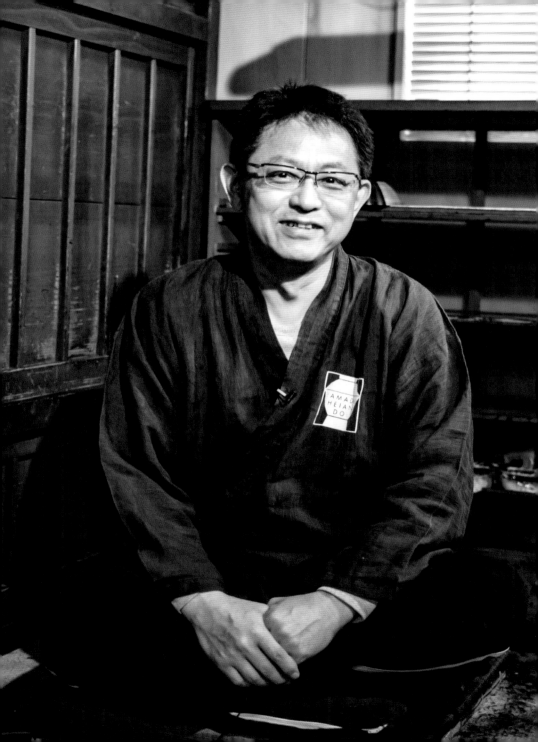

The Shokunin Interviews:

APPLYING THE FINISHING LAYER

FUMIHIKO ARAKAWA APPLIES THE THIRD and final coat of lacquer to bowls and trays in a workshop on the second floor of his home. He's a third-generation craftsman. "From my grandfather to my father to me, the work has been handed down," he says matter-of-factly. "I started this work when I was eighteen. I've been doing it for thirty years. I worked as an apprentice here in Ishikawa for ten years. I would do the work as best I could and learn from the teachers. That's the only way."

Arakawa describes his workday: "I typically start working around eight-thirty in the morning. I take a break of an hour or an hour and a half for lunch. Then I work until I am done. If I'm busy, that will be ten or eleven at night, but typically, it is more like seven or so. Also, when I am making pieces for exhibit, I find that it is quieter and easier to work at night."

He says the work is largely unchanged since his grandfather's days. "The tools are the same. We work in a traditional craft, so we're not changing to new tools. Everything is done by hand."

Arakawa's job is to make sure the thickness and coloring of the final coat is just right. A lot of that depends on how the bowls and trays dry. Humidity and temperature play a vital role. "If it dries too fast, it's no good," he says. "And if it dries too slow, that's also no good. We try to get it just right, taking into consideration the humidity and temperature. That's the most difficult part of this job."

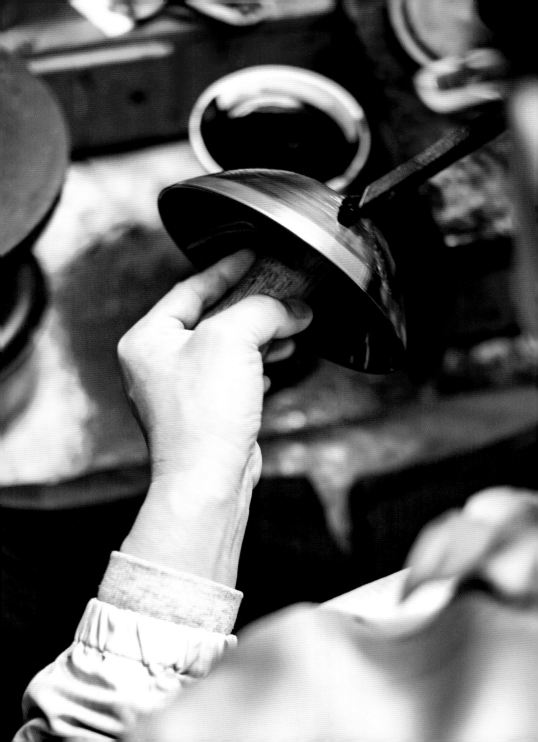

Arakawa sits on a cushion as he works. When asked if he ever gets tired of doing this work, he says, "I'm sitting all day, so my back starts to hurt. That's about it."

Arakawa's workspace has to be especially clean. The last layer needs special care because if any dust or other particles mix in with the lacquer, the product will be a total loss. "If a piece of dust or two get onto the product, it's ruined," he says. "In the old days, they weren't so particular about this aspect, but today, these items are expensive, so I want to make sure they are finished just right."

Arakawa notes that urushi has been used for centuries because of its inherently protective and useful qualities. "Urushi lacquerware began to be used long ago for waterproofing purposes," he says.

Urushi has a strong water-repellent quality, and archeologists have found evidence that it was used in the Jomon Period, the earliest historical era of Japanese history, coinciding with the Neolithic Period in Europe. That period extends back as far as 14500 BCE, but evidence of urushi use dates to somewhere around 7000 BCE. The combination of durability and beauty that urushi lacquer possesses made it irresistible to people making everything from arrow tips to religious icons. From the very beginning of Japanese culture as we understand it, urushi has played a vital role. The teacups and accessories that come with a *hina* doll for Girls' Day, celebrated on March 3, are often coated with urushi. An upscale restaurant will serve its meals in urushi–coated bowls, plates, and trays, and customers will use lacquered chopsticks to eat those meals. Urushi provides beauty and depth to everyday activities such as combing your hair, drinking a cup of tea, or sitting at a table. The Asian sap provides excellent adhesiveness, durability, and, once dried, luster.

Urushi lacquerware is also seen as uniquely Japanese by the outside world. In the seventeenth century, the Dutch East India Trading Company was given exclusive rights to sell urushi products in Europe by Japan's shogunate. This brought a surge of Japanese exports to the West. European royalty collected Japanese lacquered tables and chests. In fact, in those days, Western traders called Chinese ceramics "china," and Japanese urushi products "japan." Europeans even began making their own "japan" knockoffs to feed the growing demand for urushi lacquerware.

Today, lacquerware products can be seen as old fashioned. For example, they aren't suited to modern conveniences like dishwashers, and they must be stored away from sunlight. But urushi lacquerware has outlasted many a fad, Arakawa points out. "Urushi lacquerware dating back thousands of years has been discovered," he says. "Lacquerware has a warmth that earthenware and glass lack. For example, when you put it to your mouth, it feels soft to the touch of our lips. The bowl can feel a human's warmth. If you put your lips to a lacquered bowl and then to a plastic knockoff, I think you'll feel the difference. The knockoff has no warmth."

He continues, "I've worked on art pieces before, but now I'm working on everyday items. When I work on these items, I hope that they are used every day for people to drink miso soup or in some other way."

It's true that lacquerware needs special care, but that care is fairly simple, and the results are decades of lustrous beauty. To wash a lacquered bowl, for example, just rinse in lukewarm water with a cloth (no soap is needed), and make sure to store it away from direct sunlight. Also, keep the lacquerware away from the oven or space heaters and try to avoid too much humidity or dryness. When you are ready to use again, especially if you are entertaining, wipe with a few drops of vegetable oil, and the luster of the lacquerware returns.

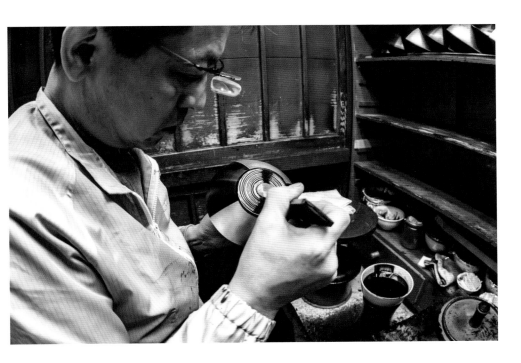

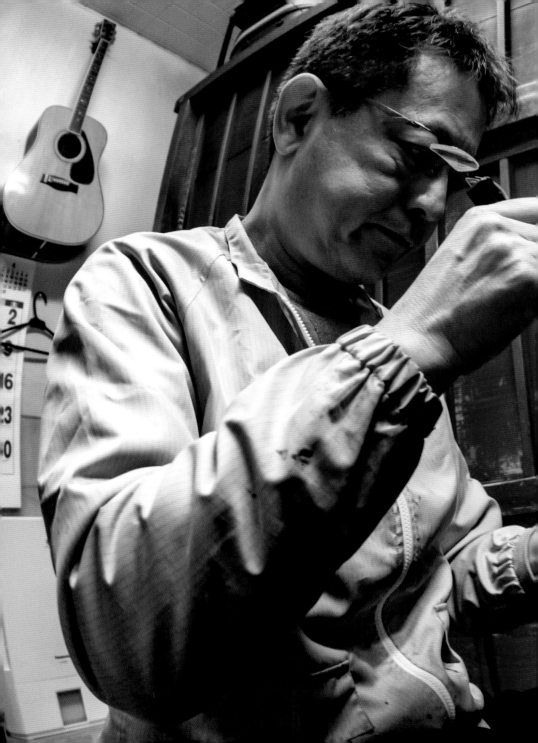

Arakawa is unassuming and soft-spoken, but in the room adjoining his office, framed certificates from the Japanese central government praising his work indicate his shokunin pride.

"I've been doing this work since I was eighteen," the forty-seven-year-old craftsman says. "When I was younger, I didn't watch my grandfather and father do this work and think, 'I want to be a craftsman.' But when I graduated from high school and thought about my career path, I strongly felt how important this traditional craftwork is. That's when I really decided that this was what I wanted to do. When I was little, I actually wanted to be a salaryman.

"I started at the level at which anyone could do the job and proceeded up the ranks to more difficult levels. After about ten years, I started to feel like I was getting the hang of it. But, actually, this is something that takes a lifetime. Every day there are new discoveries and things to learn. Just because one way worked this time doesn't mean it will work the next. There is always something new."

When I asked him who will take over his job when he decides it's time to retire, Arakawa answers, "That's a difficult question. The work has dropped off quite a bit. I'm not sure."

Arakawa and his wife have one daughter. Traditionally, women don't work in the lacquerware industry, and he doesn't expect her to follow in his footsteps, but he has no problem with breaking from tradition on this point. "As far as I'm concerned, it doesn't matter if it's a man or a woman as long as that person has the right attitude for the job."

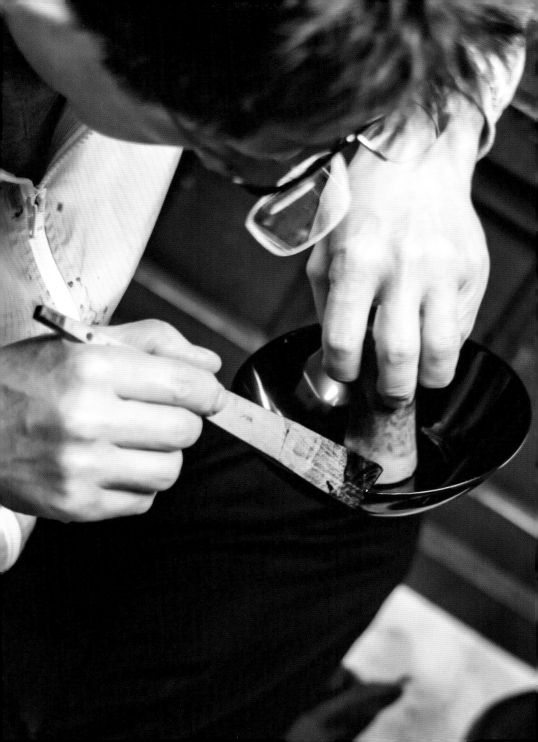

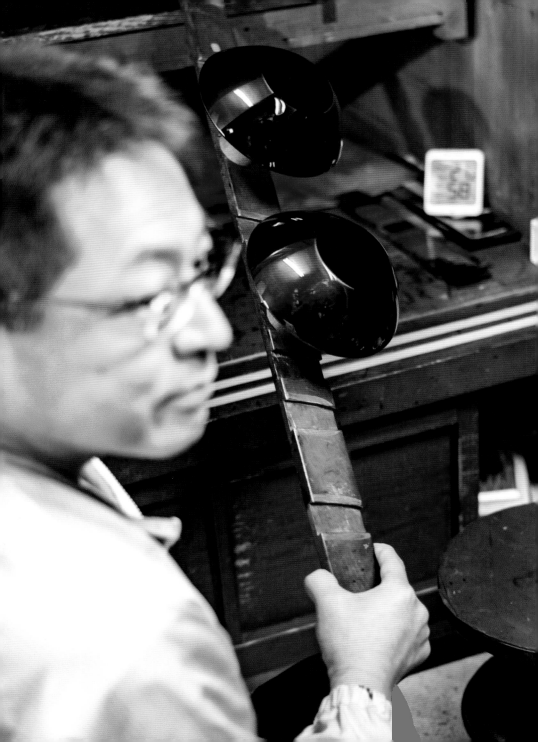

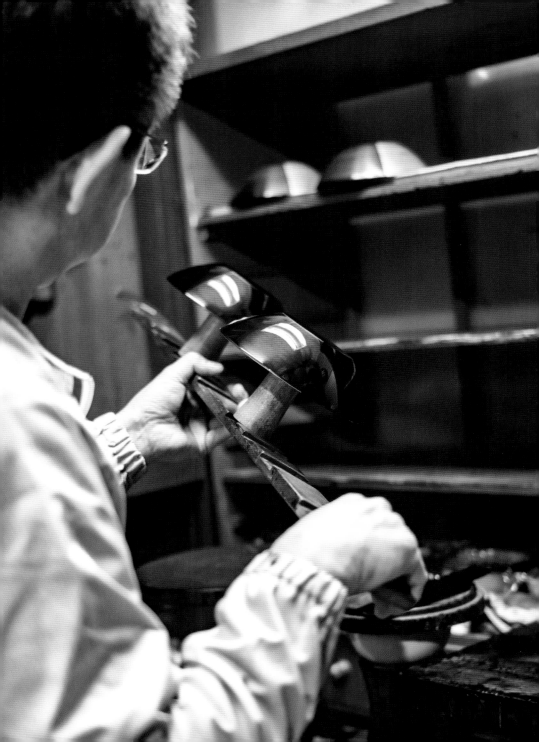

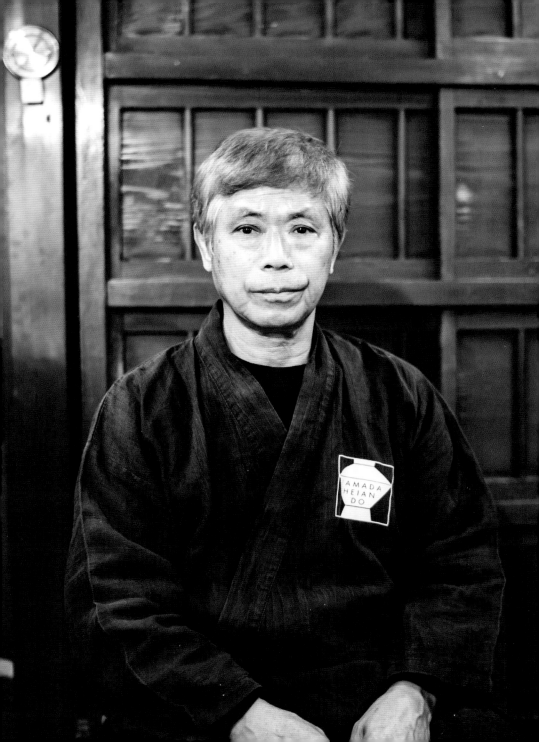

The Shokunin Interviews:

THE MAKI-E ARTIST

MAKI-E ARTIST MASAHARU SHIMO lives in a large, handsome house with a tiled roof and a stone wall marking the entrance. A well-endowed tanuki figurine by the front door stares at us. The entranceway and first floor of Shimo's house are immaculate. Shimo's wife greets us with low bows, makes sure we see the slippers waiting for us, and sends us up a steep flight of stairs to the artist's studio. The whole atmosphere feels decidedly more white-collar than our previous interviews. The silver-haired Shimo presides at his desk, the tools of his trade—fine maki-e brushes, bowls of different-colored urushi, lacquered bowls and tops, and a palette—laid out in front of him. A miniature shrine sits strategically on a ledge above him, the paper lightning bolts, tiny sake vessels, and trouble-shooting arrow watching over his work. On the other side of the room is a three-tiered wooden bird cage, but no sign of a bird inside.

Shimo's work is exquisite. On one piece, he paints a subtle branch and golden maple leaves. Beside it, the pink-hued urushi is used to create cherry blossoms. He works quickly but methodically.

"I've been doing this work since my teen years," he says, "so I've been at it for fifty years."

Shimo says he still gets a thrill when he sees his handiwork displayed in a private home or a restaurant. "I see my work all over the place and am

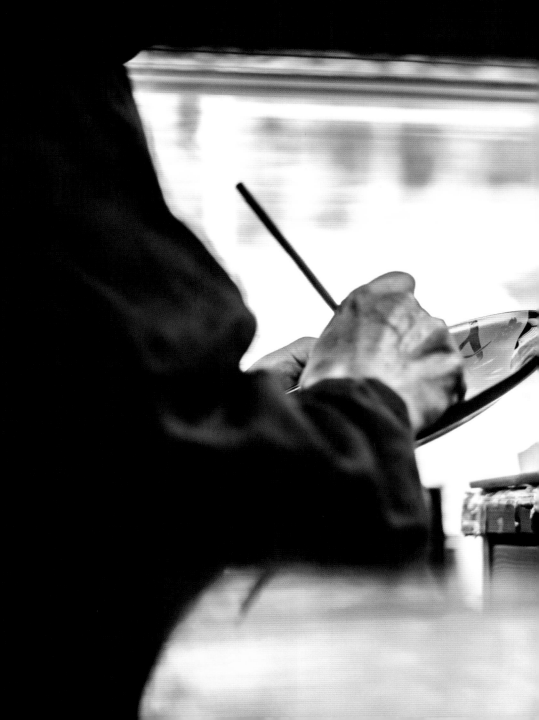

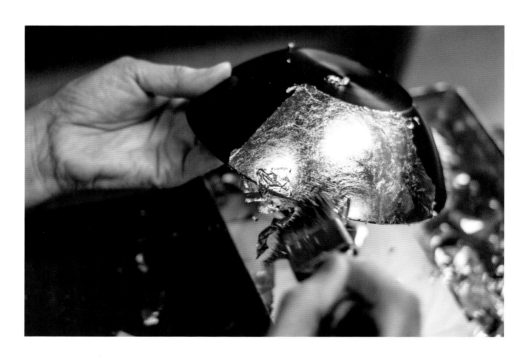

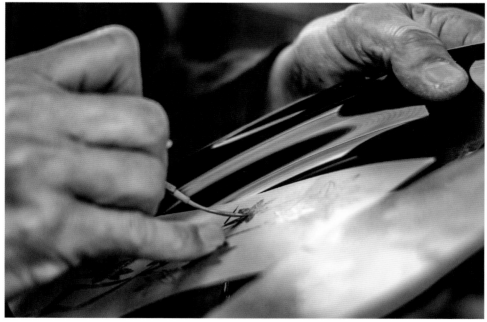

always surprised," he says. "It makes me proud when I hear my work is seen as a keepsake."

Off to the side of his studio is a tiny room with a large fan in the wall. This is where he works with the gold dust, to minimize the chance of foreign objects getting into the work. He taps his brush, and tiny gold flakes cascade onto the lacquerware. Amazingly, he does this while the urushi is still wet, which takes expert skill and years of experience to master. Shimo can create cascading designs of gold and silver on the wet urushi, to stunning results. This process is known as *nashi-ji*.

He makes a foil paste that few in the world are capable of making. He is skilled in the art of *kinpaku*, in which the paste is turned into a sheet of pure gold as thin as 1/10,000th of a millimeter. The sheets are carefully placed onto items in what looks like seamless fashion. These sheets are so thin that light can shine through them, but once placed on a bowl or a plate, they give the illusion that the item is made of pure gold.

Kinpaku is a dying art. "There are very few successors waiting. If my generation can continue, I want to give it my best effort," Shimo says fatefully, as if being resigned to the fact that he may be the last person on Earth to have these skills.

Throughout the workday, Mrs. Arakawa pops into his studio to offer a helping hand. She'll check to see which pieces have dried and even help make the foil paste. She works efficiently and expertly; it's evident she has been her husband's assistant for a long time, although she is quick to deflect any praise.

"There are so few maki-e successors left," Shimo says. But he and his wife press on, quietly making exquisite works of art in their second-floor studio.

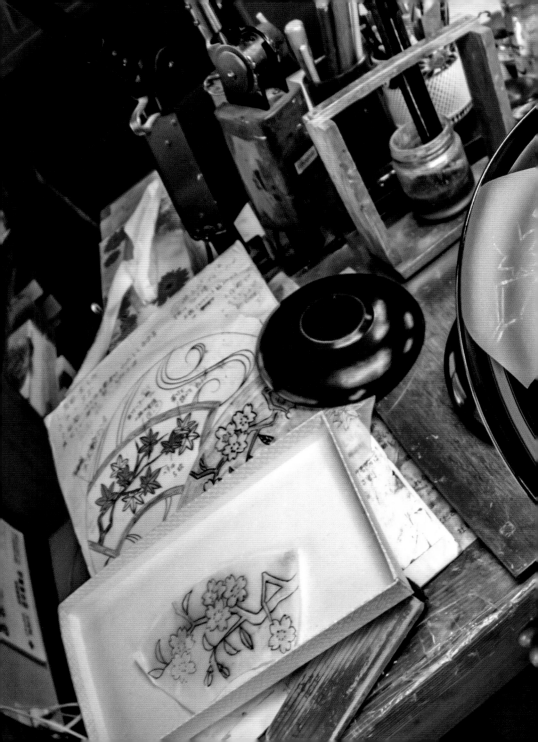

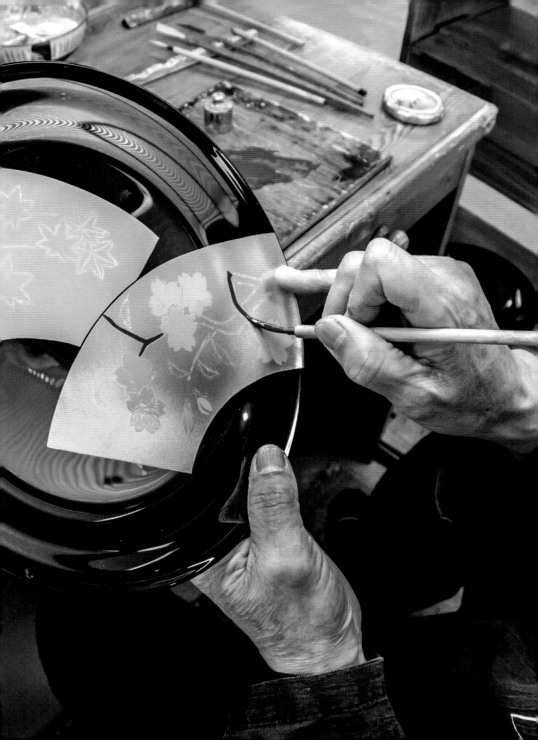

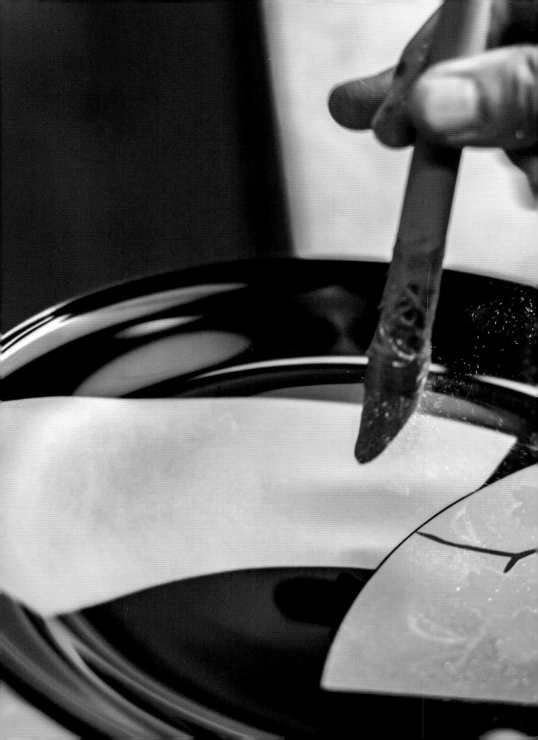

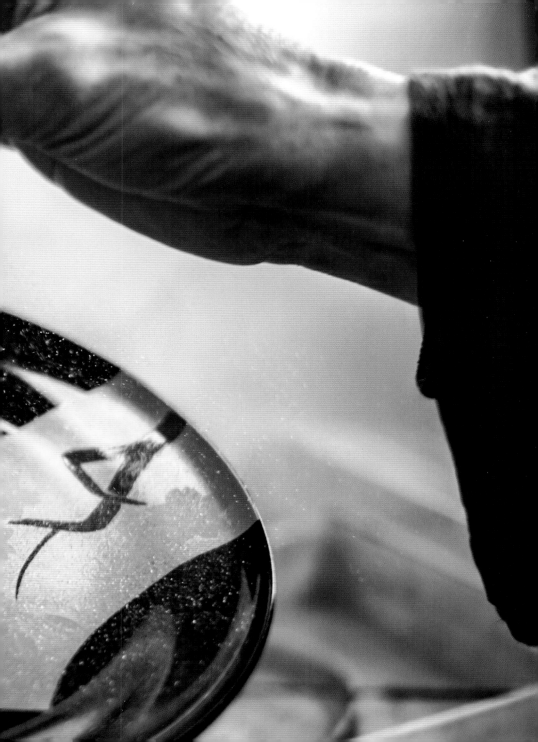

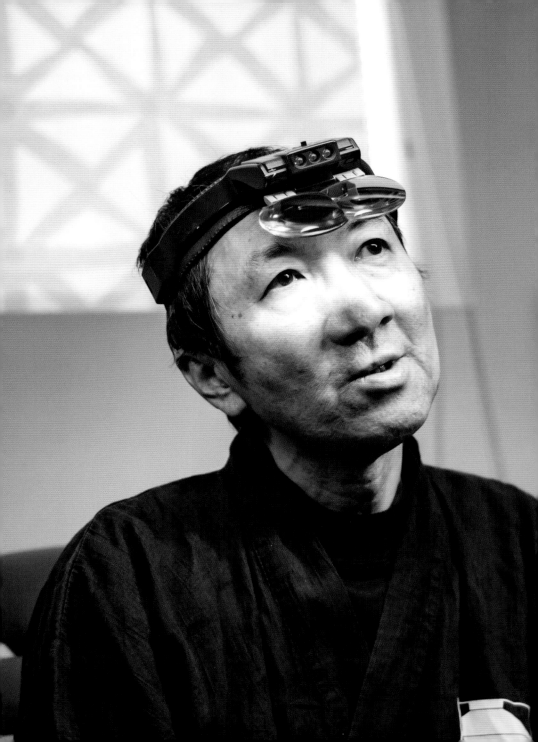

The Shokunin Interviews:

MODERN MAKI-E APPLICATIONS

MINORI KOIZUMI, FIFTY-EIGHT, is a living example of "*kodawari*," a Japanese term that is tricky to translate but hints at obsession. Think Bill Evans on the keyboard, Ichiro Suzuki in the batting cage, Meryl Streep with a script. Koizumi is a master maki-e artist who lives in Echizen, Fukui Prefecture. Urushi trees used to grow in the hills outside his home. Koizumi wears a visor with 3X magnified lenses that he flips down to peer through. He looks a little like a mad scientist as he focuses in on the tiny surfaces where he paints his masterpieces.

"It's difficult to see with the naked eye, but I want people who look at my work with a magnifying glass or who zoom in on it with a camera to be impressed. I want the lines to be clean. If the finish isn't done right, that's no good. So I work hard to get it right. This is in my character," he says of his penchant for fine detail that goes beyond what the human eye can perceive. "It's an obsession of sorts. I guess you call it craftsmanship. That's the most important thing."

Koizumi uses lacquer to paint on the watch faces of high-end Swiss watchmaker Chopard. He paints figures of the Chinese zodiac in lush environments. A tiger slinks by a bamboo grove. A monkey picks an apple from a hanging branch. A pig stands in a field, wild grass in the foreground, a tree and bushes in the distance. All of these scenes are painted with painstaking detail.

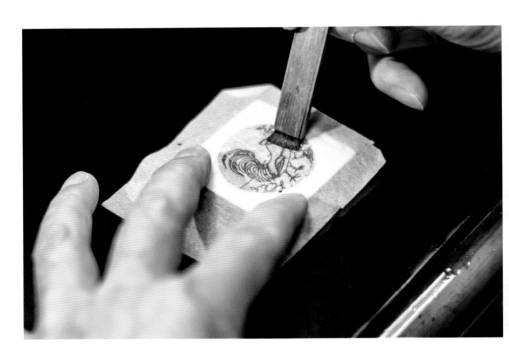

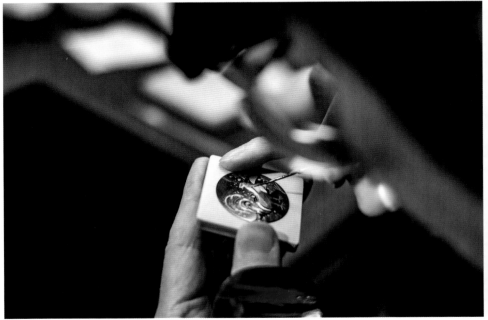

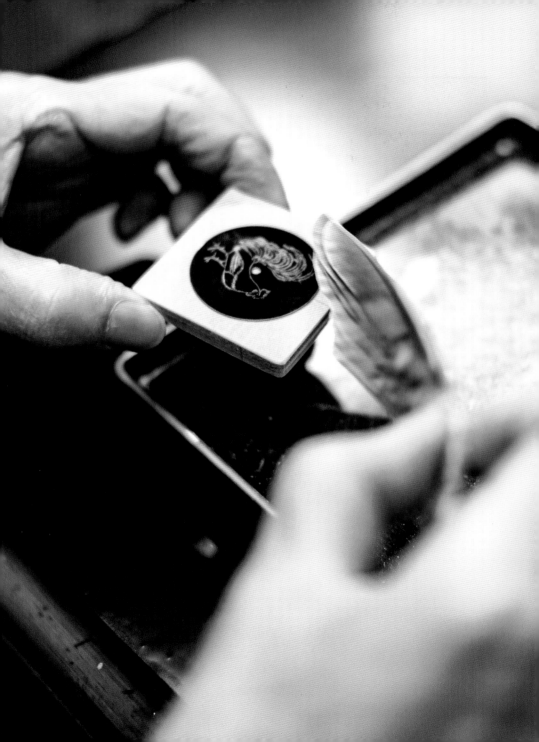

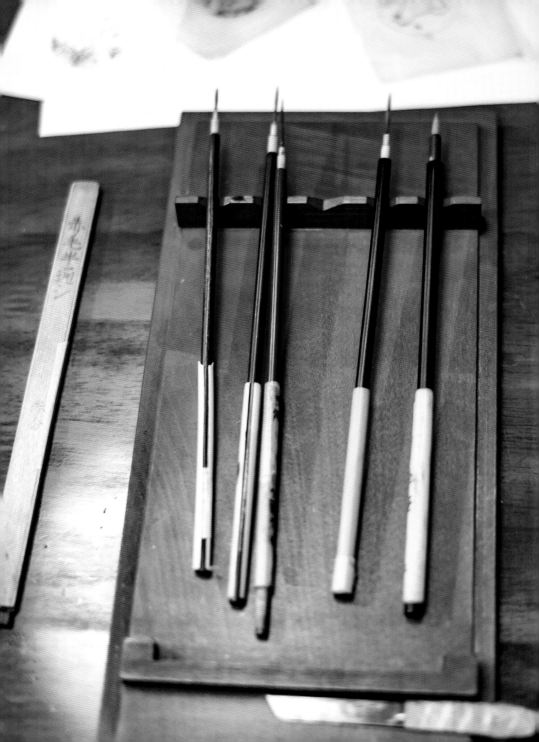

Lacquerware maker Heiando has been working with Chopard for a decade on the Chopard LUX XP urushi watch series. Heiando has assigned the work to Koizumi, and he seems to be the perfect fit. His work is exquisite. He says each watch face takes two weeks, including drying time. His watch for 2020, the Year of the Rat, features a cute little mouse (the Japanese language does not have a different word for "rat" and "mouse"—both are "*nezumi*") crouching on an ear of corn. A green-leaved sapling has accents of blue, and a pumpkin sits off to the side. Koizumi made eighty-eight of these watches, and each one has a price tag of about $25,000.

When asked why he spends so much time on details that can't be seen by the naked eye, he has a ready reply: "It's a luxury item. The customer is expecting the very best. It's a beautiful watch, so even if you can't quite see all the detail with your eyes, I want the customer to look at the watch and know it's done right. I'm a little obsessive about it. I consider that the totality of my work, the most important part."

Despite the fact that he is painting watch faces for a Swiss watchmaker, Koizumi contends that he is doing "classical Japanese work," the calling of a true shokunin. He says modern conveniences have made his craft harder, not easier. For example, the quality of the urushi shokunin's tools has dropped over the centuries.

"I use brushes, and there are limits to what the brushes can do," he says. "The mouse-hair brushes made hundreds of years ago were better than the ones we have today. With modernization, the environment that mice are living in has worsened, and we can't find good mice. And the people making the brushes have passed on, so it's becoming harder and harder to find good brushes. I have to show patience as I work with these inferior tools."

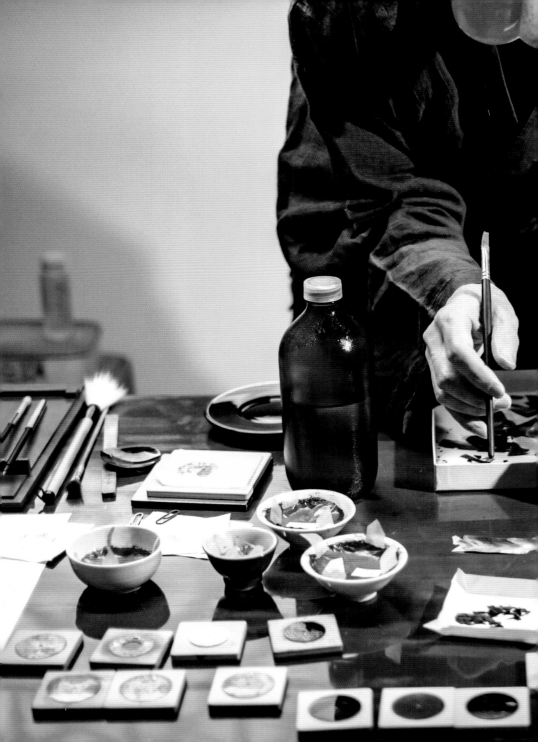

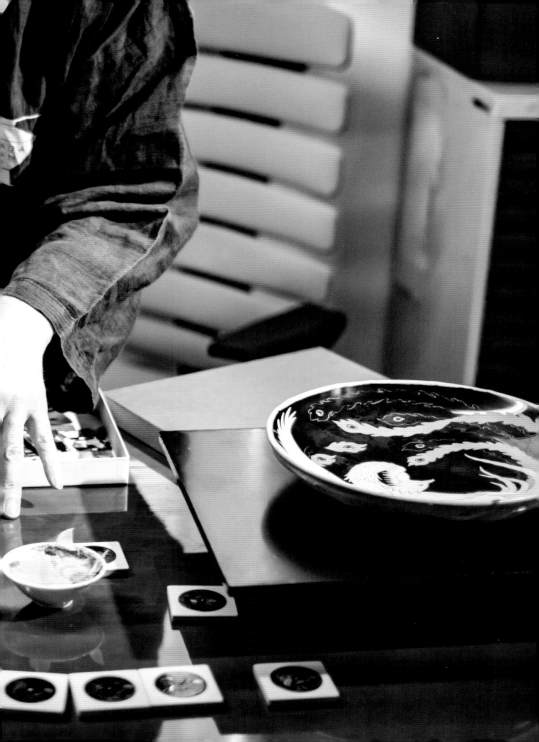

I ask Koizumi what the most challenging aspect of his work is. "It's very detailed, and from the beginning to the end of the process, we must polish, clean, and apply layers over and over," he replies. "The chores begin to pile up. We don't go through the routine just once. We must do it over and over. And to complete a piece, we have to adjust and make sure that each step is done correctly so that at the end, when we're finished, it is the best piece it can possibly be. I think that's the most difficult part about this work."

Koizumi knew he wanted to be an urushi craftsman from a young age. "Since I was a little kid, I always liked drawing more than studying. I wasn't much of a student," he says.

When he graduated from high school, he decided to join an apprenticeship taught by a lacquerware master. "There were a lot of lacquerware teachers in Wajima then," Koizumi says of the town at the very northern tip of the Noto Peninsula on the Japan Sea.

Wajima, a town of 28,000, is a mecca for lacquerware fans. The town's famed morning market, where women hawk foodstuffs (fresh seafood, local sweets, etc.) and lacquerware along Asaichi-dori avenue , is more than a thousand years old. It's said that the women formed the market long ago to barter for goods and food while the men worked in the lacquerware trade. The women still dominate today; they give the market its good-humored, hard-working character. Every morning from eight to noon, the city's main street is flanked by stalls and flooded by shoppers from around the world. It was near this dynamic marketplace that a young Koizumi learned his trade.

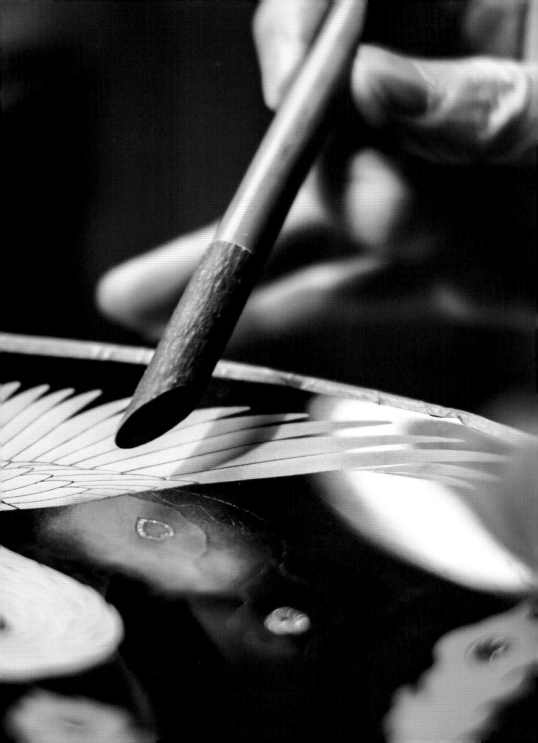

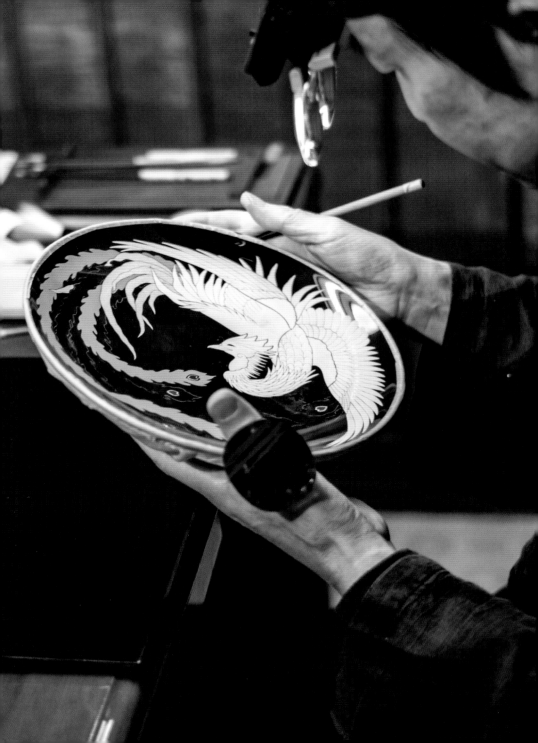

He spent seven years there studying under various teachers, including one who had been designated a living national treasure. "I never once thought about quitting," he says "I learned so much from so many people. There were difficult times, but nothing I couldn't handle." When he returned to Echizen, Koizumi was twenty-six.

Today, Koizumi represents the hopes for urushi craftspeople who desperately need to connect with companies and art aficionados overseas. His watch work for Heiando and Chopard is an example of Japanese lacquerware appealing to Europeans in a new way.

European collectors have been fans of urushi for centuries, ever since Portuguese Jesuit missionaries were attracted to the lacquerware in the seventeenth century. However, supply has always been limited and the market remains relatively small.

Still, the urushi trade has proven resilient, surviving in one way or another for centuries.

"The traditional Japanese craft of maki-e has continued for hundreds of years," he says. "I want my customers to feel that attractiveness."

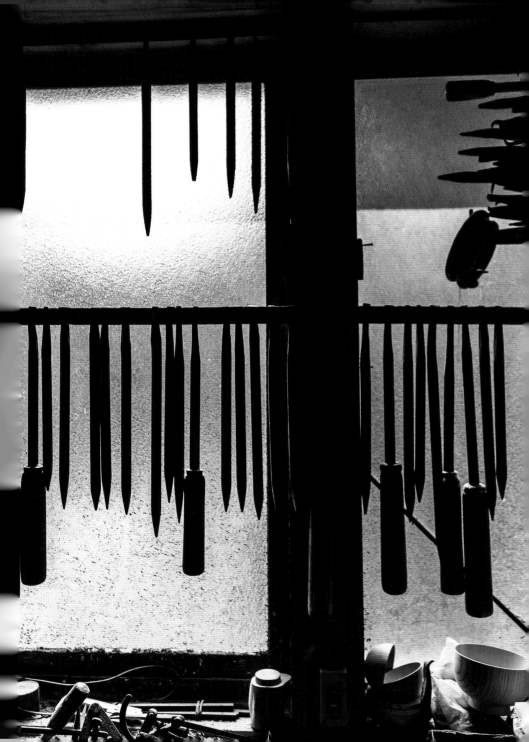

POSSIBLE FUTURES

THE ISHIKAWA PREFECTURAL INSTITUTE for Yamanaka Lacquerware is a short walk from Tanaka-san's house. The showroom hosts a display of lacquerware created by students and local artists. There are rows and rows of not only expertly crafted trays and bowls but also a lacquered bicycle, modern drinking glasses and jewelry, and a workshop where people can watch the shokunin carve bowls out of wood. In an adjoining room, a trunk of an urushi tree with the horizontal slashes in it shows how the sap is drawn out.

A large display on one wall shows the many ways urushi can be used in design, bringing out distinctly different colors and patterns. This is a far cry from the traditional blacks and reds Japanese lacquerware is known for. We learn that there are different types of urushi trees, whose sap has varying qualities, and that the same urushi tree can produce very different lacquer depending on the season in which it is tapped. There is urushi that becomes paler as time passes, urushi that is known for its durability, transparent urushi, and many more types of lacquer that produce everything from coal black to pale yellow colors. And, of course, all of this lacquer can become a canvas for maki-e artists, who use a variety of powders, including gold dust, to create designs on the lacquer's surface.

The institute draws mostly young people from all over the country to learn the craft. Classes are small and intense. There is a basic course and a specialist course. Each are limited to five students per semester, and tuition is subsidized by the government, making it very affordable. Annual tuition for the basic course is 221,000 yen

(about two-thousand dollars) with another thirty-thousand yen for supplies and a few extra charges that add up to less than one hundred dollars or $150 depending on whether you are from Ishikawa Prefecture or elsewhere.

Both the basic course and the specialist course require two years of study to graduate. This sort of hands-on learning used to be done through apprenticeships, in which young men would come to Yamanaka Onsen and learn at the foot of one of the many master craftsmen in the area. They would stay five, six, seven years, learning the craft before they were ready to set out on their own.

In Japan, masters typically expect students to learn by observation and through trial and error. In the old days, the sensei didn't deliver lectures and there was no textbook. Today, at the institute, the approach to learning has become more formalized, but the bottom line is that this is a craft that must be learned through hands-on experience.

The urushi trade has long been a male one, but the institute is attracting plenty of female students . The class of 2018 had forty-six women and sixty-seven men. This is a good sign for the urushi trade. While preserving some tradition is important, other, less inspired traditions, such as separating the roles of men and women in society, end up stifling innovation and hastening the demise of trades that could use a feminine infusion. Even the conservative Prime Minister Shinzo Abe has called for more inclusion of women in the workforce. Welcoming women into the urushi industry makes all sorts of sense.

There's also a clear desire among Japan's younger generation to connect with the best of Japan's past. Several factors have led to this. Japanese young people have been reassessing their priorities in recent decades,

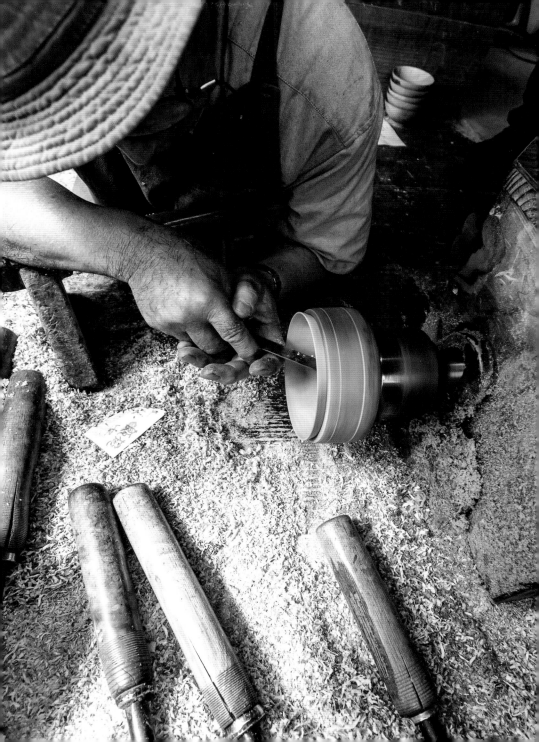

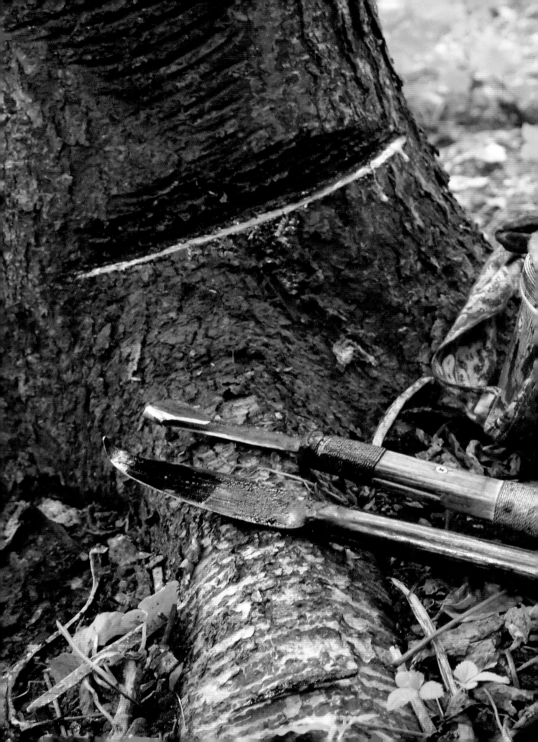

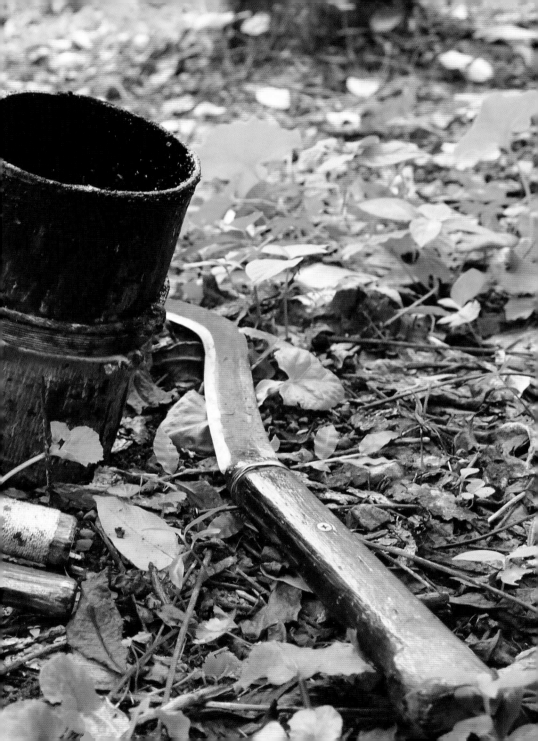

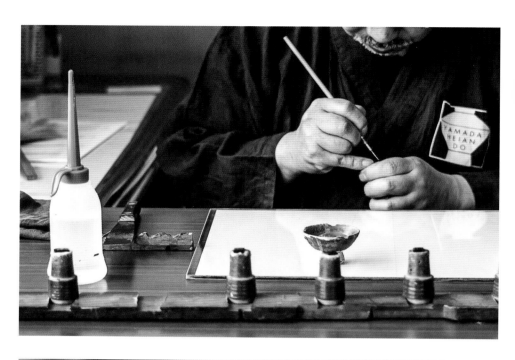

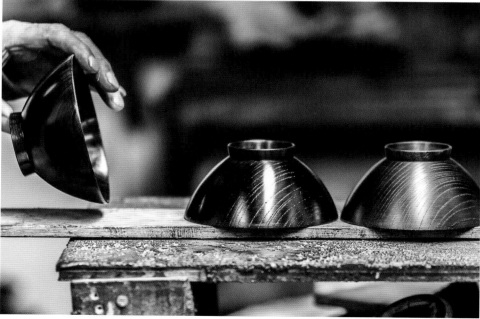

often out of necessity. The go-go economy of the 1980s is a hazy era their moms and dads talk about. Today's youth have grown up with constant deflation. That's all they know. The days of "lifetime employment" seem as far away to them as samurai culture.

In fact, this change in attitude came into stark relief after the 2011 tsunami and nuclear meltdown. Months after that catastrophe, the Hakuhodo Institute of Life and Living found evidence that young Japanese were taking stock of their lives and adjusting their values. Researcher Mariko Fujiwara found that young Japanese showed a "growing sense of personal responsibility" and a "desire to contribute to society." Young adults are now more likely to volunteer and are exploring their spirituality. The sweet poems of Misuzu Kaneko, a poet who killed herself almost a century ago, came roaring back into the public consciousness after the tsunami. People renewed their interest in Buddhism and Shintoism. Hideko Yamashita's DanShaRi books exploring the decluttering phenomenon from a spiritual aspect sold millions. Since the tsunami, Japan has been in a reflective mood.

As young Japanese increasingly look back to reconnect with what is best in their culture, there is hope for traditional crafts—well, at least a little hope, because as the great journalist Studs Terkel was fond of saying, hope dies last. The road to salvaging the urushi industry for centuries to come will be a difficult one, but here's hoping Tanaka, Arakawa, Shimo, Koizumi and their peers are not the last of their breed. Here's to a new generation of men and (especially) women who learn at the feet of the few masters Japan has left and carry on the centuries-old art of urushi lacquerware. And here's to more art connoisseurs across the globe rediscovering the beauty of urushi. If the true beauty of this art form is appreciated on a wider level, the craft could have a lustrous future.

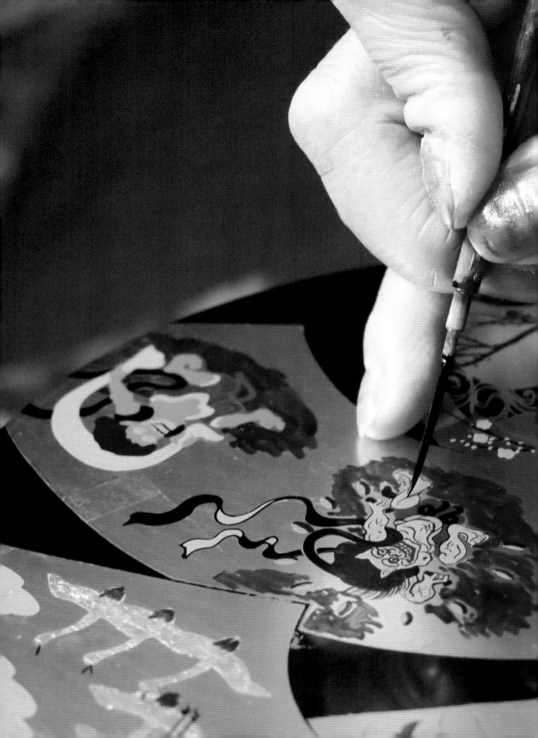

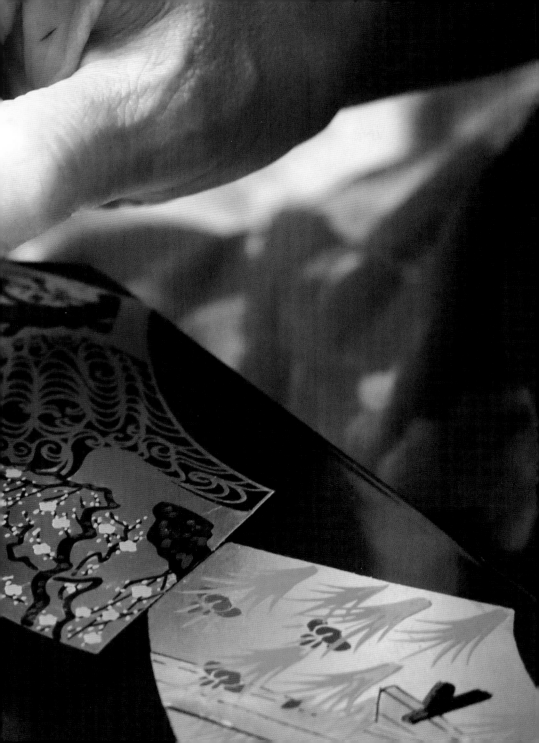

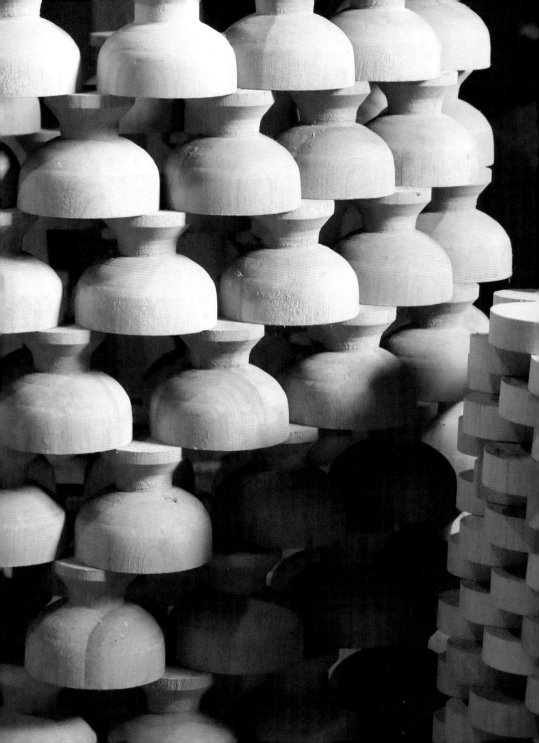

GLOSSARY

hina dolls | Traditional dolls displayed in homes with daughters. The dolls come with accessories such as teacups and trays that were often coated with urushi.

Kamakura-bori | Designs are carved into wood, and then urushi is layered on top.

keyaki | Wood from the Zelkova serrata tree, which is highly prized by craftspeople in Japan for its beautiful grain.

kiurushi | Raw urushi sap after it has been filtered.

kinpaku | The art of making very thin sheets of pure gold that are layered onto bowls, trays, etc.

kodawari | Loosely, obsession for one's craft.

maki-e | A technique of painting images on the lacquerware using powdered gold, silver, and other colors.

nashi-ji | A form of maki-e in which gold and/or silver flakes are sprinkled onto the surface of wet lacquer.

raden | A lacquerware technique in Japan using mother-of-pearl and seashells.

shokunin | A traditional Japanese craftsperson.

tonoko | A powder made from wheat flour and rice.

urushi | Sap from the Asian lacquer tree.

urushi-e | Patterns and pictures painted with different-colored urushi sap.

urushiol | The oily sap from the urushi tree, also found in poison ivy and poison oak.

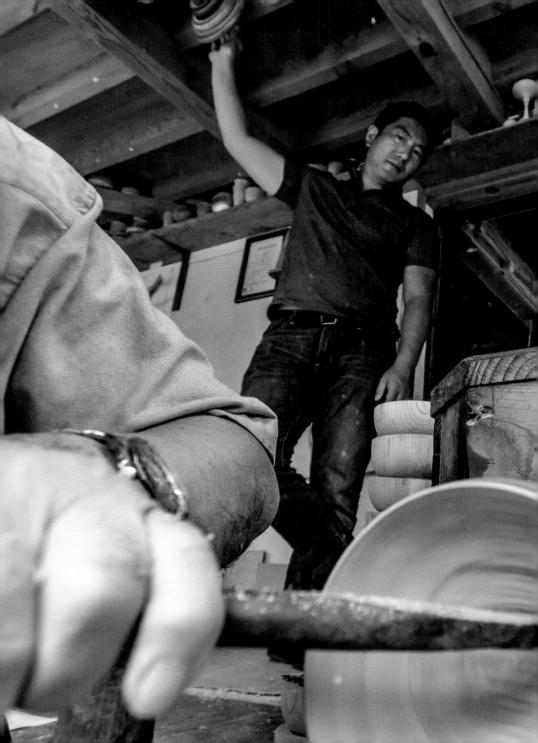

ABOUT YAMADA HEIANDO

YAMADA HEIANDO IS A JAPANESE lacquerware brand that has been producing some of the world's finest *urushi* lacquer products for more than a century. Company founder Konosuke Yamada trained for years to become a lacquer artisan before opening his shop in Tokyo in 1919. His lacquerware soon became famous for its elegance and its bold use of color. The Emperor of Japan took notice, and Yamada Heiando has been a proud purveyor of tableware to the Japanese Imperial Household ever since.

Today, Yamada Heiando products grace the lobbies and offices of Japan's international embassies. They are also used in some of the country's most sacred temples and shrines.

The company's mission is to help more people discover the beauty of urushi lacquer. The company continues its time-honored practice of using only the best materials and the most skilled craftspeople to create urushi lacquer pieces in bright red and black, sparkling *maki-e* gilding in gold, and delicate *raden* inlays of mother-of-pearl, to name just a few of the styles and techniques in its arsenal.

The family-owned company is run by Kenta Yamada, who took over from his father in 1996 and became the fourth-generation heir. In the twenty-first century, the company has looked overseas for partners and opportunities to bring urushi lacquerware to a global audience. Today, it collaborates with chocolatiers, watchmakers, and other international brands, shining a new light on the beauty of urushi lacquer.

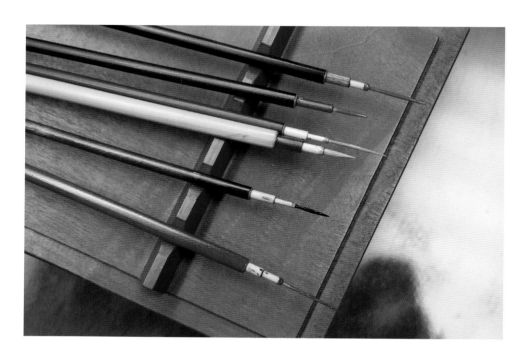

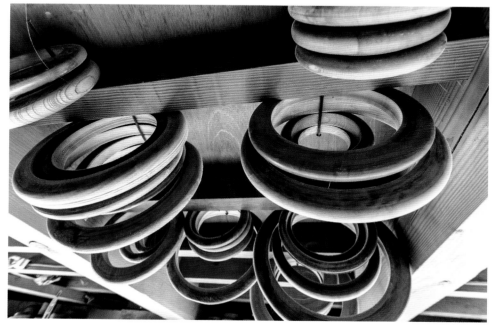

Yamada Heiando's main office and flagship store is in the Daikanyama neighborhood of Tokyo at:

G-202 Hillside Terrace
18-12 Sarugaku-cho
Shibuya-ku, Tokyo
150-0033 Japan

ABOUT HEIANDO AMERICA

HEIANDO AMERICA, BASED IN SEATTLE, is a wholly owned subsidiary of Yamada Heiando. The American branch engages in sales and marketing activities and actively seeks partners for collaborative projects. For more information, please visit www.heiandoamerica.com or call 425.749.1050.

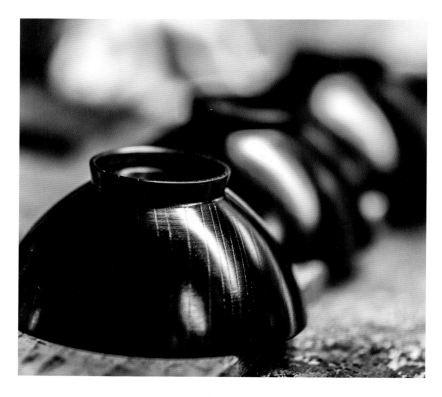

INTERESTED IN LEARNING MORE about Japanese lacquerware?
Use this QR code to watch a video about the craft.